Patterning Techniques

Doodling and patterning are wonderful ways to embellish your images to make them unique to you and really stand out! You can add doodles to a design before coloring or after. Adding doodles after coloring works best on designs colored with markers, as described below.

G000065641

Before Coloring

1 Start with a blank design.

2 Add little doodles like lines, circles, and other shapes. Patterns are just simple shapes that are repeated!

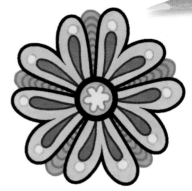

3 Color the design.

After Coloring

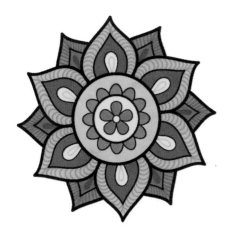

1 After coloring a design with markers, add details using fine-tip pens.

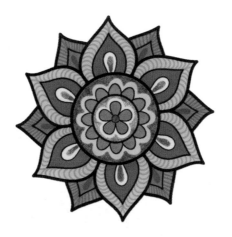

2 Add more details using gel pens (I used glitter gel pens here).

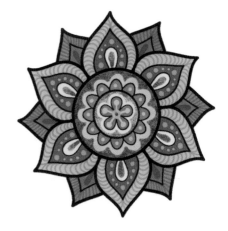

3 Add a final layer of detail using paint pens.

Tips

- Try adding details with pens, gel pens, paint pens, fine-tip markers, colored pencils, and anything else you can think of!
- Try layering different media on top of one other to see what effects you can create.

Shading

Shading is a great way to add depth and sophistication to a drawing. Even layering just one color on top of another color can be enough to indicate shading. And of course, you can combine different media to create shading. Here are two techniques to try!

Shading by Outlining

If you've never tried shading before, start with this easy outlining technique to help make your images pop! In this example, markers were used for both the base colors and the outlines, but you could also create the outlines with pens, gel pens, or colored pencils.

 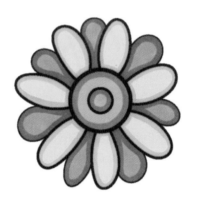 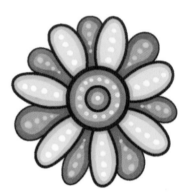

1 Color the design.

2 Use darker colors to outline the shapes within the design, like the two center circles of the flower and each of the petals.

3 For a little extra pizzazz, add dots!

Shading Colored Pencils on Top of Markers

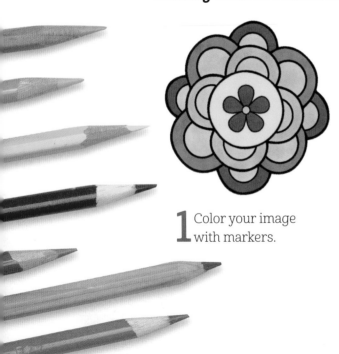 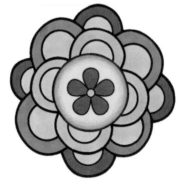 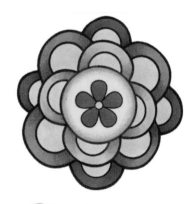

1 Color your image with markers.

2 Use darker shades of your base colors in colored pencil to add shading. Here I used orange pencil to shade the yellow marker.

3 I used magenta and violet pencils to add shading to the pink marker areas.

Blending

Blending allows you to make smooth transitions between different tints and shades of a color when shading, and even between two different colors when creating gradients. Here are some simple techniques to produce flawless blends.

Alcohol-Based Markers

Alcohol-based markers can create smooth blends that have a painted look. You only need two colors to create a blend, but in this example I've used three shades of the same color: a light, a dark, and a color in between.

Tips

- It's easiest to create smooth transitions while your base layer is still damp.
- Don't be afraid to really work the marker into the paper—alcohol-based markers won't tear or pill the paper.
- Put a sheet or two of scrap paper underneath your coloring page to soak up any excess color that may seep through the paper.

1 Color your entire image with the lightest color. While this is still damp, use your middle color to add shading, focusing on the sides and bottom half of the shape.

2 Using your lightest color, go over the edges where the two colors meet to soften the transition.

3 Use your darkest color to add deeper shadows, focusing on the very outer edges and bottom of the shape.

4 Use your middle color to soften the edges between the dark and middle colors. If needed, use your light color on top of everything to smooth the transitions even more.

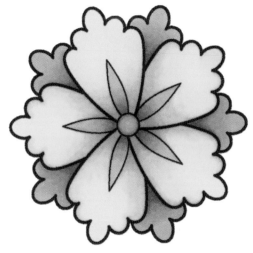

All of the colors in this flower were blended. Note the transitions from yellow to orange, from light pink to magenta, and from light blue to medium blue.

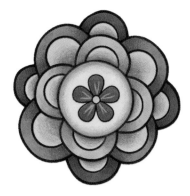

4 I used a dark blue pencil to shade the light blue marker areas. You can also use a white pencil to add details on top of the marker, as I did in the flower's center.

Tips

- When using colored pencils, apply more pressure to the areas that you want to appear darker.
- Use light-colored pencils on top of dark areas to create highlights.

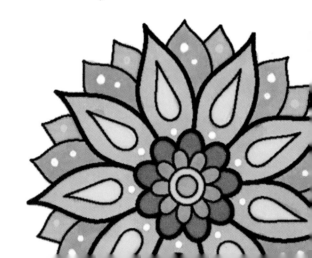

Colored Pencils

In this example I've used three shades of each color:
a light, a dark, and a color in between.

1 Color the design with your lightest colors. Then, lightly apply your middle colors over the areas that you want to appear darker.

2 Lightly apply your dark colors where you want the deepest shadows. Apply more pressure where you want the color to be the strongest.

3 Use your middle colors to go over the area where the middle and dark colors overlap. Apply pressure as necessary to smooth the transitions.

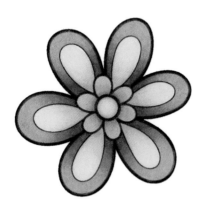

4 Use your lightest colors to go over the areas where the light and middle colors overlap, applying pressure as needed.

Tips

- Applying a colored pencil in a circular motion makes the color appear more seamless than if you use back-and-forth strokes.
- Always use light pressure at first, and apply more pressure as you add more layers.
- A slightly blunt colored pencil works better for this technique than one with a super sharp point.

Colored Pencils with a Blender Pencil

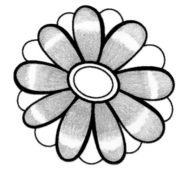

1 Lightly apply color using small overlapping circles (as opposed to back-and-forth strokes). Leave areas completely white where you would like to create highlights.

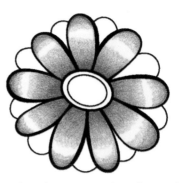

2 Using the same colored pencil and the circular motion, go back and add a second layer of color, applying more pressure to the areas that you want to appear darker.

Colored Pencils with Baby Oil

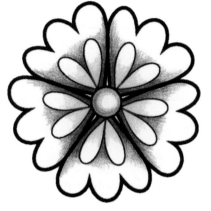

1 Color the darkest areas first.

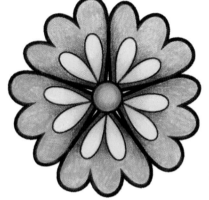

2 Next, color in the lighter areas.

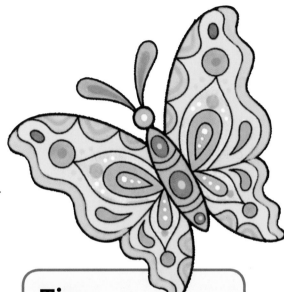

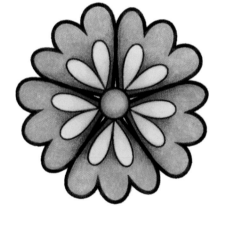

3 Dip a cotton swab or tortillon (paper blending stump) into baby oil. Blot the excess on a paper towel. Gently rub the swab over the colored areas. Use a different swab for each color group. After the baby oil has dried, you can add more color if needed, and use more baby oil to blend it.

Tips

- You can apply as many colors and layers as you like before applying the baby oil.
- A little baby oil goes a long way. It helps to pour a small amount into a watercolor palette or small container.

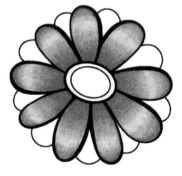

3 Go over everything with a blender pencil, using it the same way you would use a colored pencil. The blender will smooth your colored pencil marks and increase the intensity of the color.

4 You can create additional shading using a darker color, as I've done at the end of each petal. Repeat these steps with different colors for the rest of your design.

Tips

- Practice on scrap paper to see the various results you can produce by mixing different colors.
- After you apply the blender pencil, the surface of the art will be slick, so you might not be able to apply more colored pencil on top.

Color Theory

One of the most common questions beginners ask when they're getting ready to color is, "What colors should I use?" The fun thing about coloring is that there is no such thing as right or wrong. You can use whatever colors you want, wherever you want! Coloring offers a lot of freedom, allowing you to explore a whole world of possibilities.

With that said, if you're looking for a little guidance, it is helpful to understand some basic color theory. Let's look at the nifty color wheel in the shape of a flower below. Each color is labeled with a P, S, or T, which stands for Primary, Secondary, and Tertiary.

Working toward the center of the six large primary and secondary color petals, you'll see three rows of lighter colors, which are called tints. A **tint** is a color plus white. Moving in from the tints, you'll see three rows of darker colors, which are called shades. A **shade** is a color plus black. The colors on the top half of the color wheel are considered **warm** colors (red, yellow, orange), and the colors on the bottom half of the color wheel are considered **cool** colors (green, blue, purple). Colors opposite one another on the color wheel are called **complementary**, and colors that are next to each other are called **analogous**.

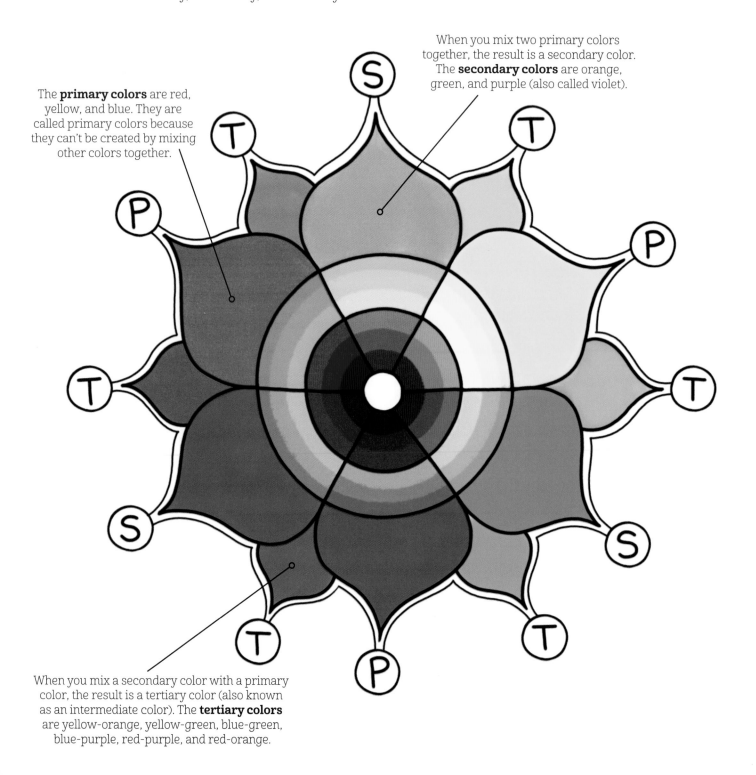

When you mix two primary colors together, the result is a secondary color. The **secondary colors** are orange, green, and purple (also called violet).

The **primary colors** are red, yellow, and blue. They are called primary colors because they can't be created by mixing other colors together.

When you mix a secondary color with a primary color, the result is a tertiary color (also known as an intermediate color). The **tertiary colors** are yellow-orange, yellow-green, blue-green, blue-purple, red-purple, and red-orange.

Color Combinations

There are so many ways to combine colors that sometimes it can be overwhelming to think of the possibilities...but it can also be a ton of fun deciding what color scheme you are going to use!

It's important to remember that there is no right or wrong way to color a piece of art, because everyone's tastes are different when it comes to color. Each of us naturally gravitates toward certain colors or color schemes, so over time, you'll learn which colors you tend to use the most (you might already have an idea!). Color theory can help you understand how colors relate to each other, and perhaps open your eyes to new color combos you might not have tried before!

Check out the butterflies below. They are colored in many different ways, using some of the color combinations mentioned in the color wheel section before. Note how each color combo affects the overall appearance and "feel" of the butterfly. As you look at these butterflies, ask yourself which ones you are most attracted to, and why. Which color combinations

feel more dynamic to you? Which ones pop out and grab you? Which ones seem to blend harmoniously? Do any combinations seem rather dull to you? By asking yourself these questions, you can gain an understanding of the color schemes you prefer.

Tip

Now you're ready to start experimenting on paper. When you're getting ready to color a piece of art, test various color combos on scrap paper or in a sketchbook to get a feel for the way the colors work together. When you color, remember to also use the white of the paper as a "color." Not every portion of the art piece has to be filled in with color. Often, leaving a bit of white here and there adds some wonderful variety to the image!

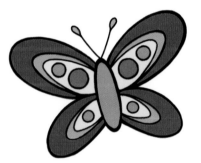

Warm colors

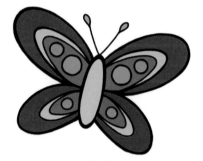

Cool colors

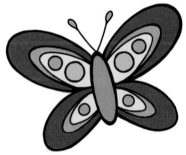

Warm colors with cool accents

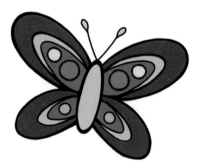

Cool colors with warm accents

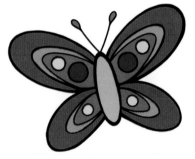

Tints and shades of red

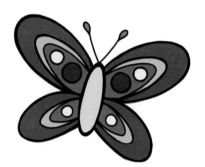

Tints and shades of blue

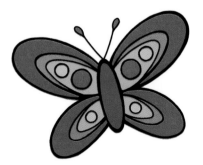

Analogous colors

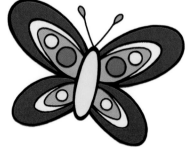

Complementary colors

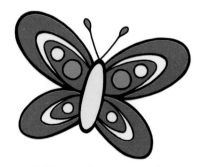

Split complementary colors

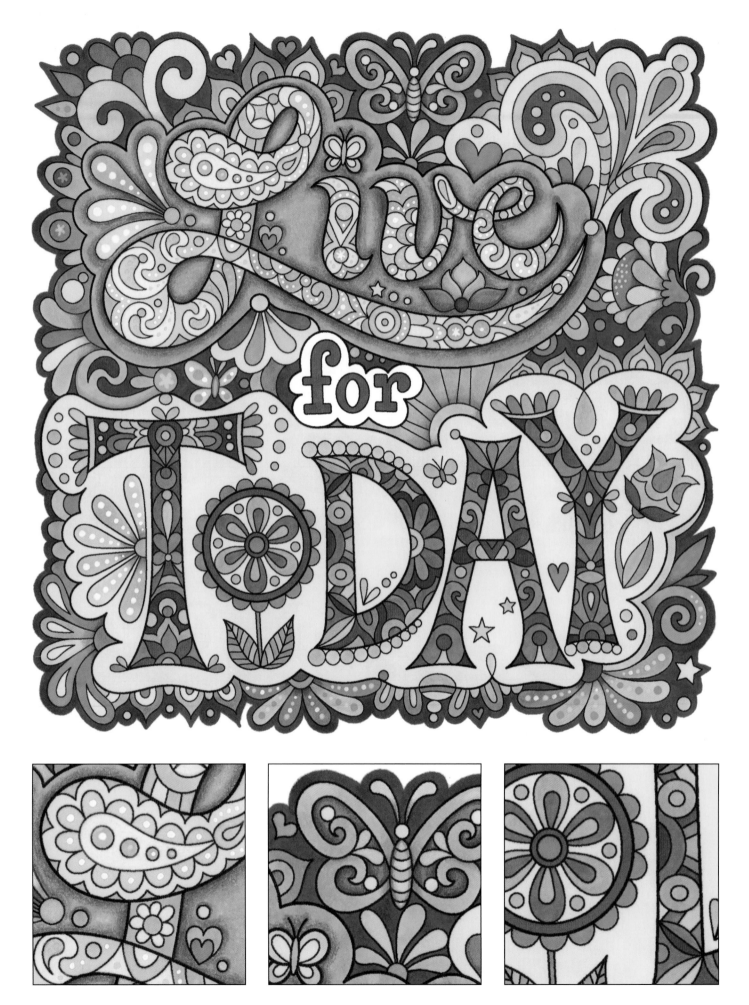

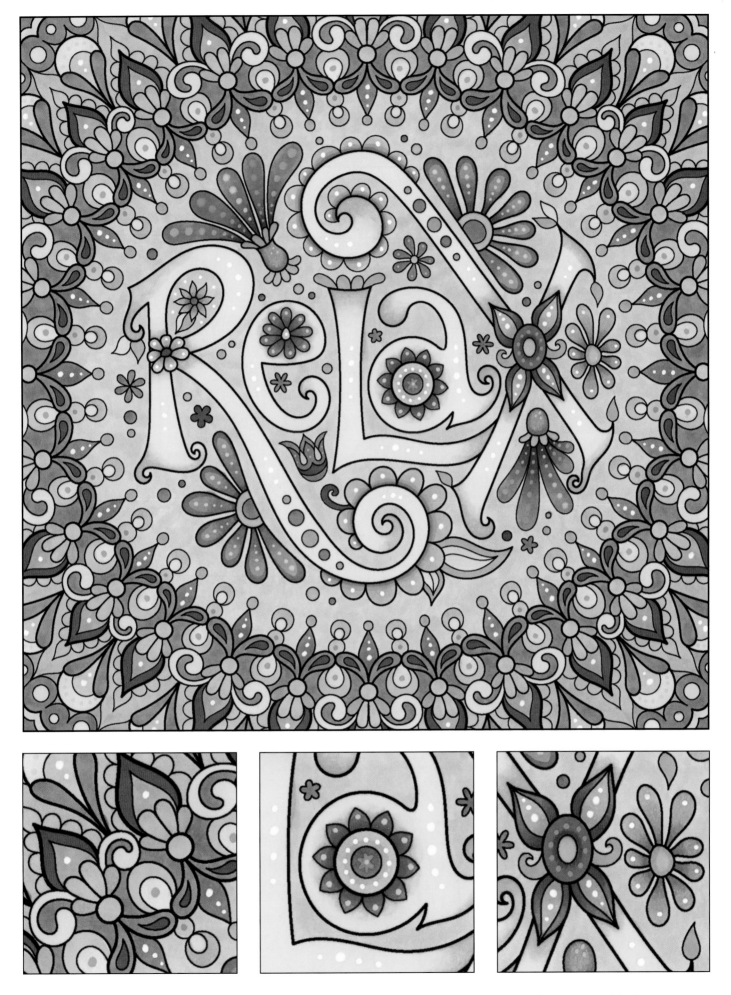

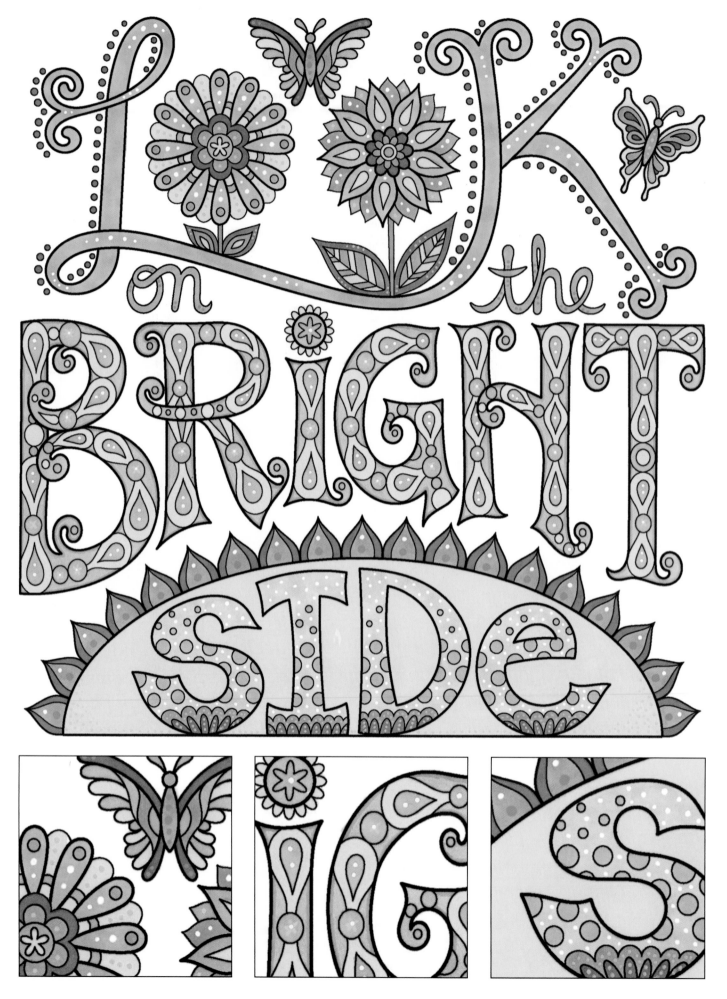

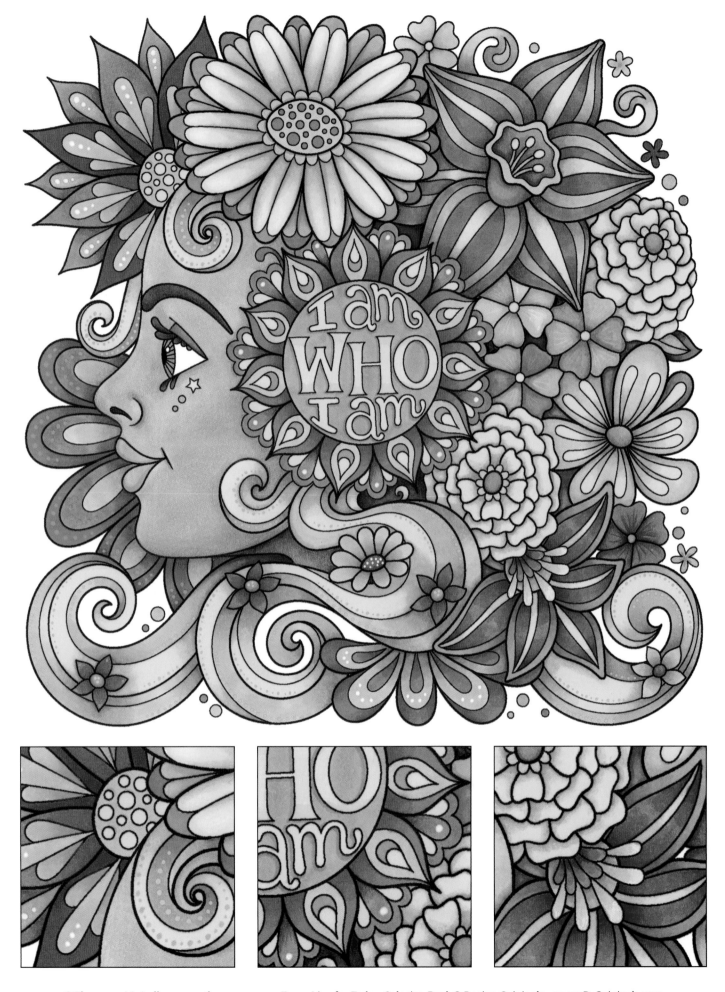

The image contains the text: "I am WHO I am"

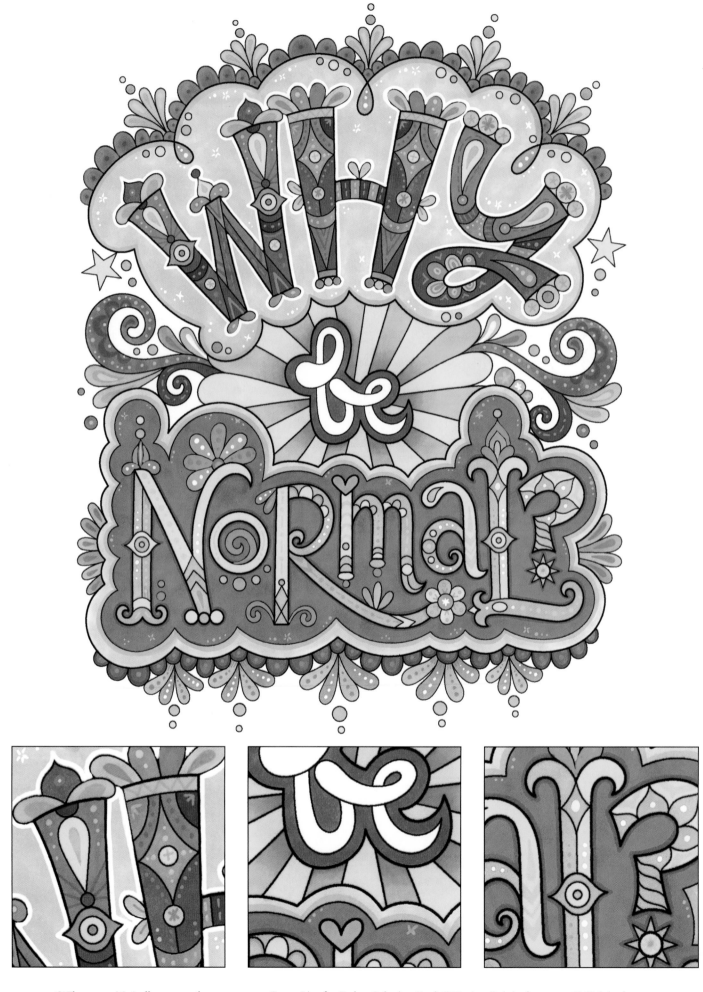

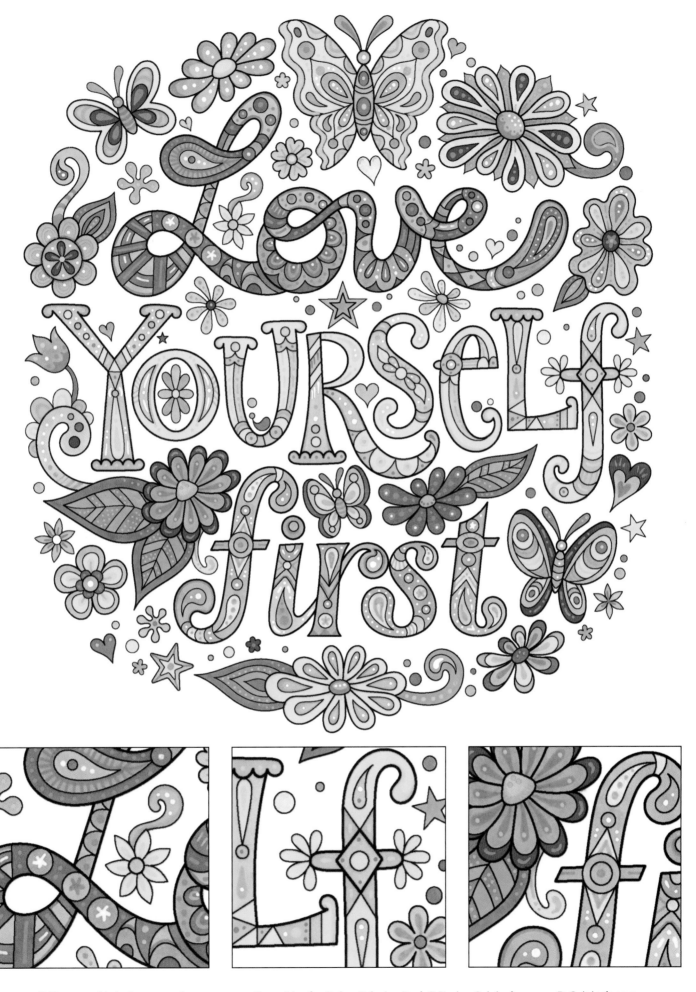

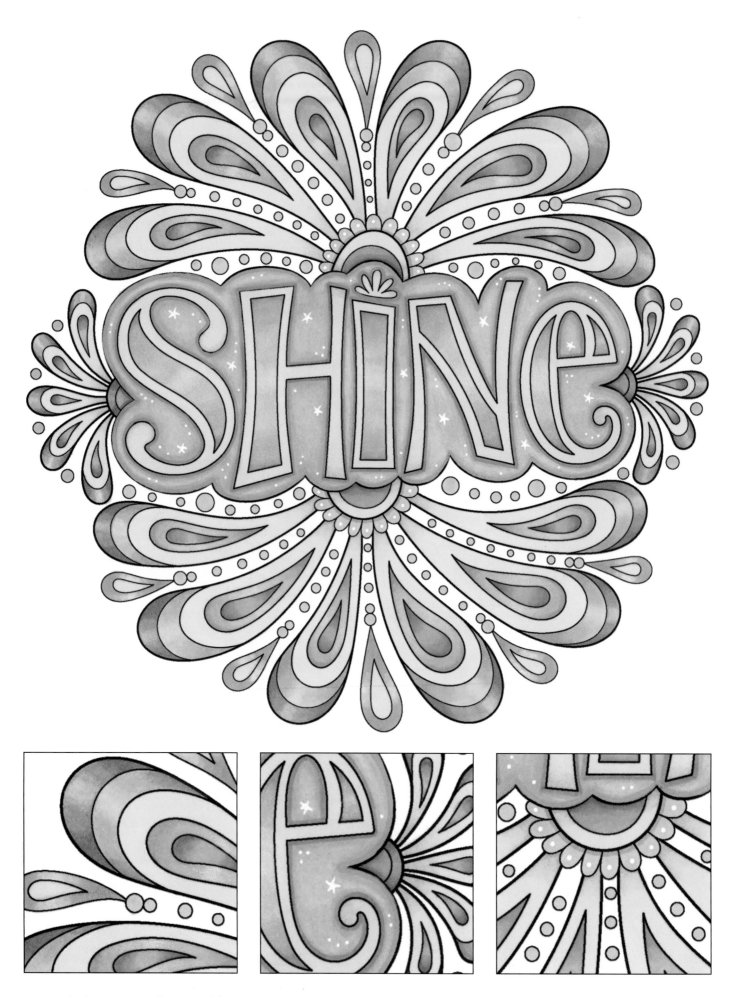

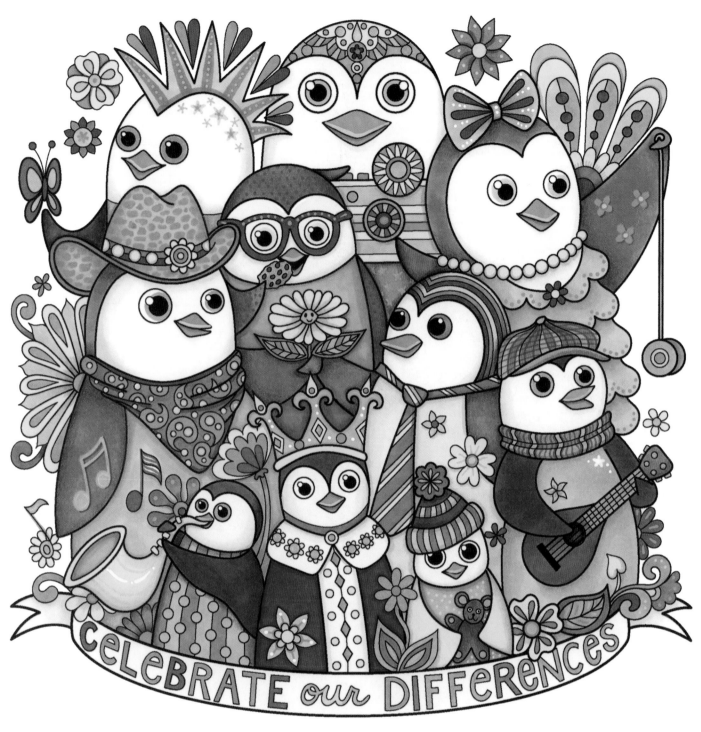

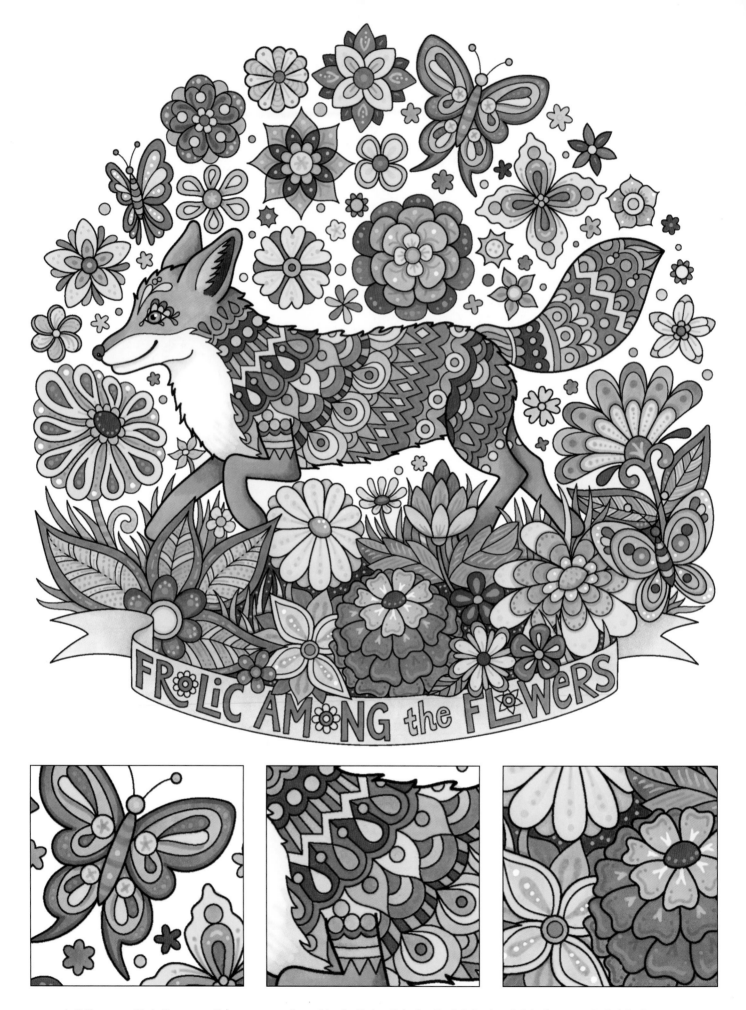

FR LiC AM NG the FL WERS

Enjoy the little things in life for one day you'll look back and realize they were the big things.

—Kurt Vonnegut

The TIME is NOW

Life is now.
There was never a time
when your life was not now,
nor will there ever be.

—Eckhart Tolle

Take more chances, dance more dances.

—Unknown

Today's special moments
are tomorrow's memories.

—*Aladdin 2: The Return of Jafar*

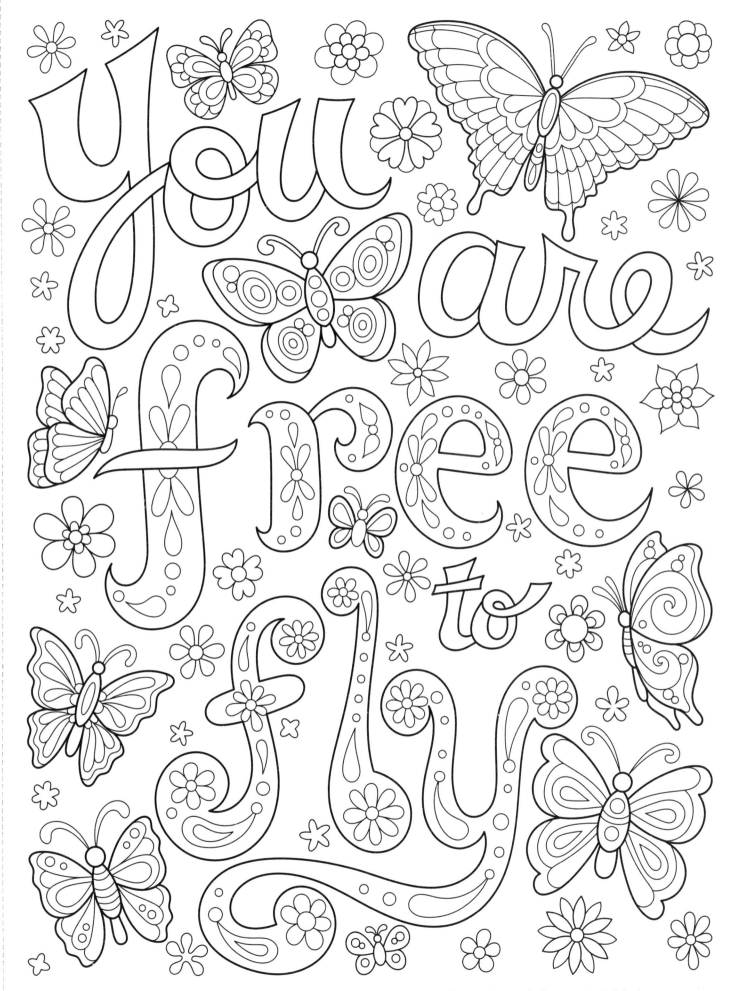

Until you spread your wings you
have no idea how far you'll fly.

—Unknown

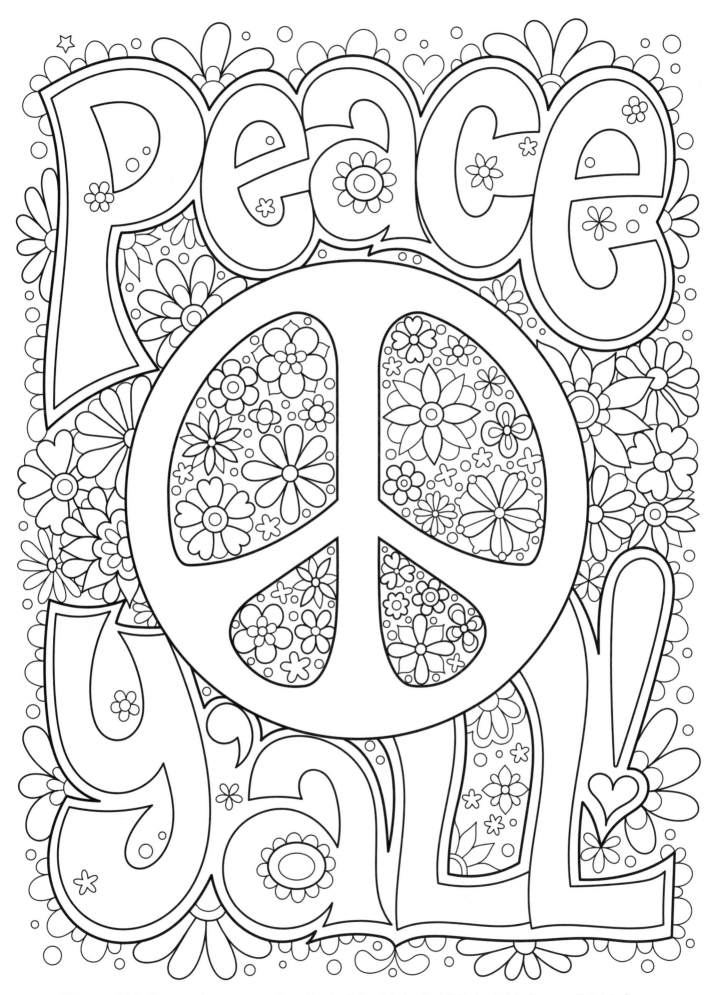

Have a light heart
and a happy soul.

—Unknown

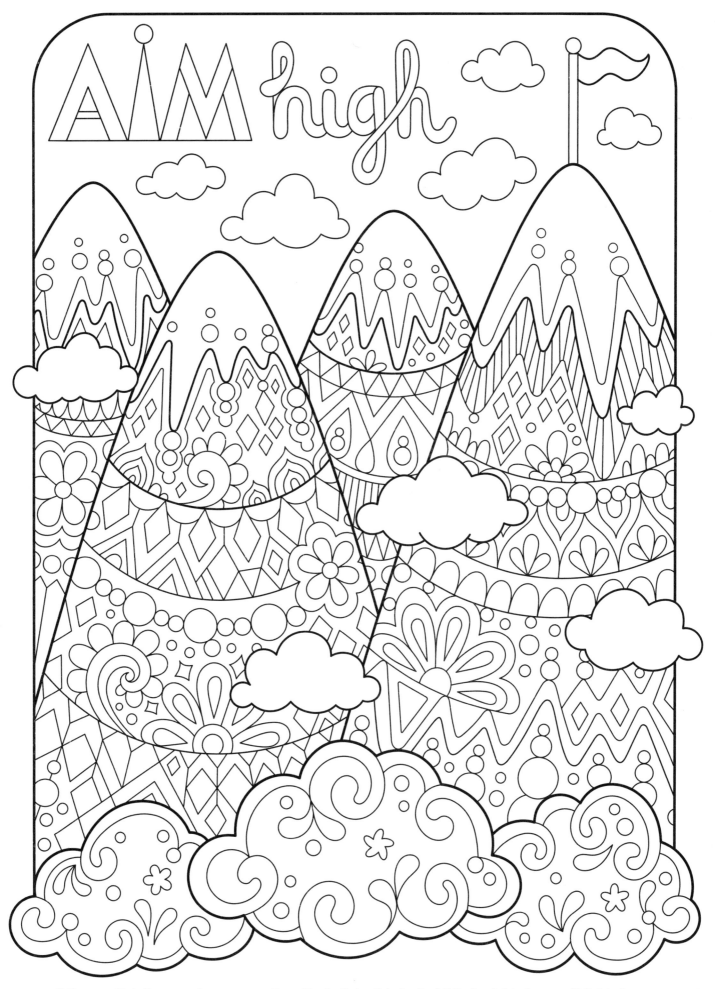

If your dreams do not scare you,
they are not big enough.

—Ellen Johnson Sirleaf

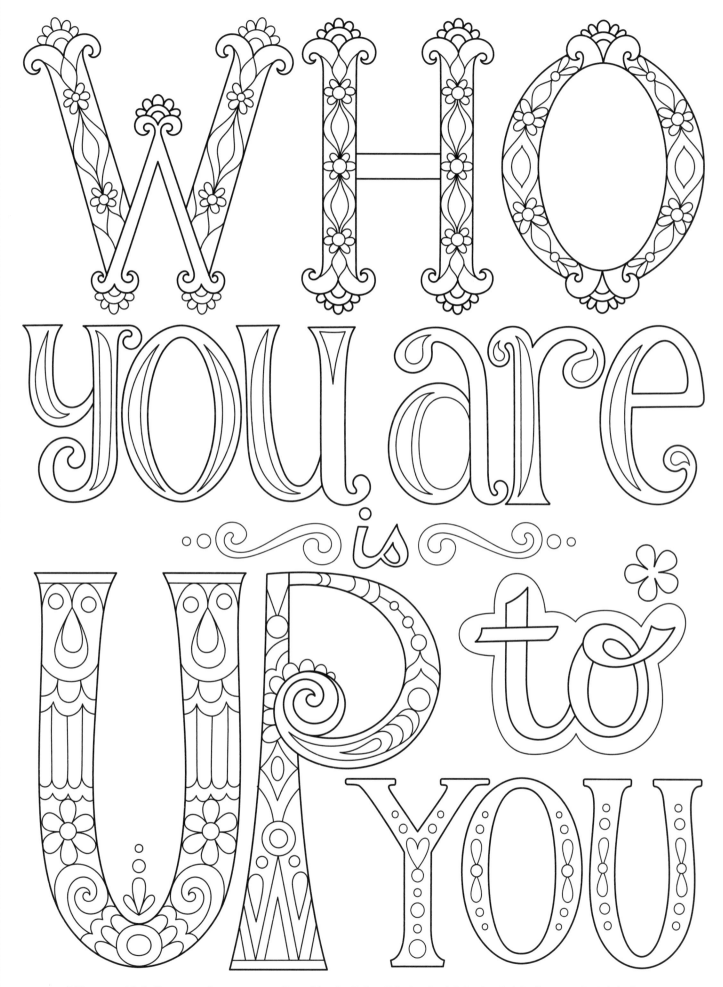

WHO you are is UP to YOU

It takes nothing to join
the crowd. It takes everything
to stand alone.

—Hans F. Hansen

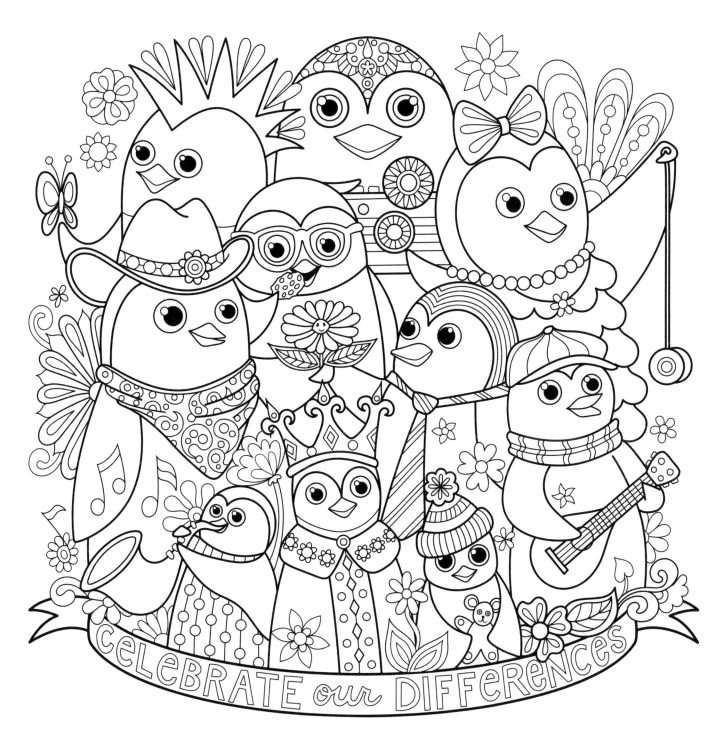

celebrate our DIFFERENCES

This design uses a cool color palette with pops of warm colors for contrast.

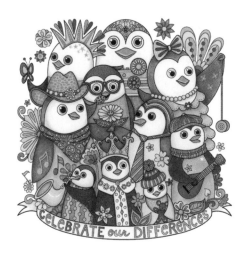

Share our similarities,
celebrate our differences.

—M. Scott Peck

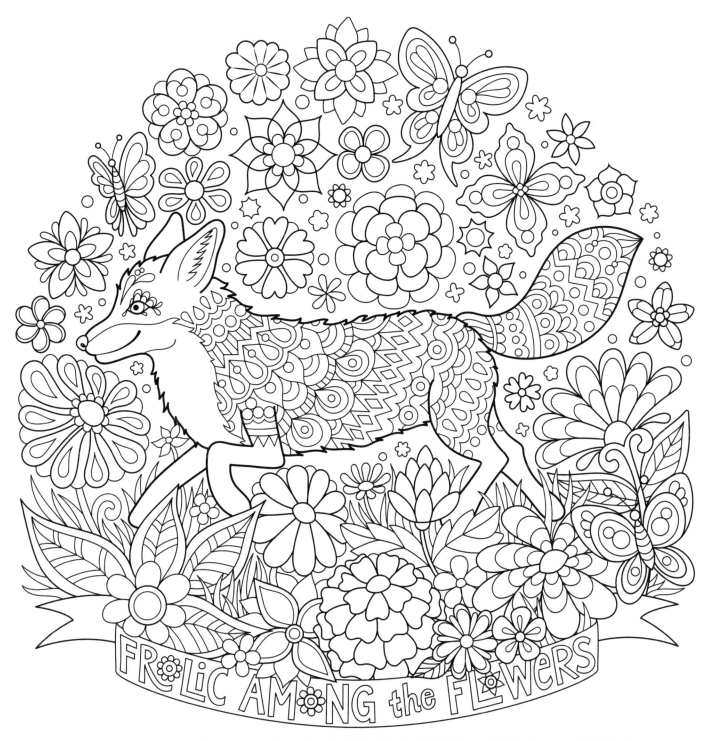

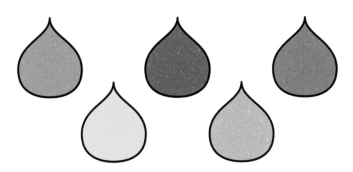

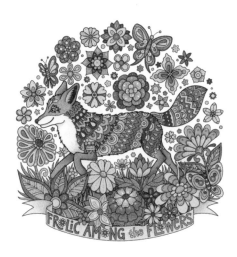

Take inspiration from nature by coloring the fox with oranges and browns, but add pops of bright, fun colors for a playful twist.

As you walk down
the fairway of life
you must smell the roses,
for you only get
to play one round.

—Ben Hogan

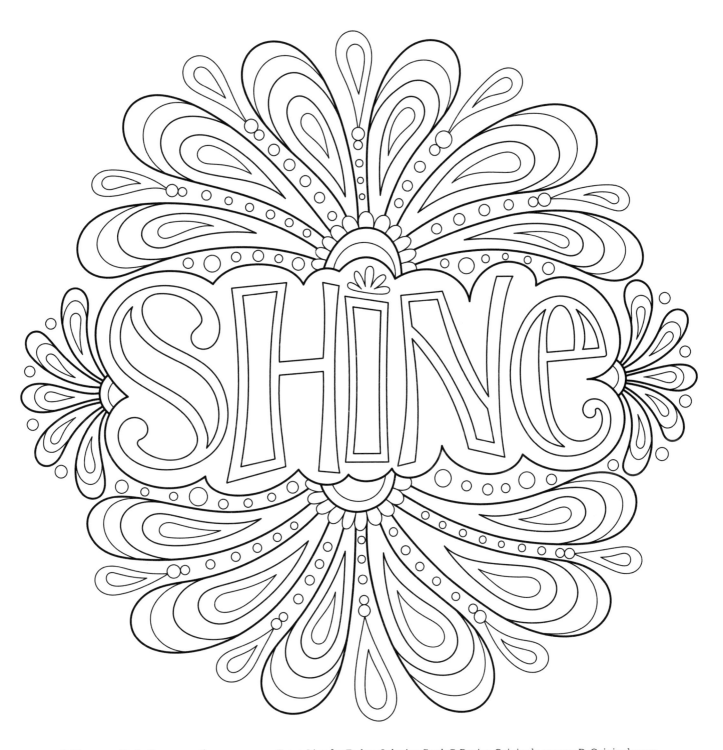

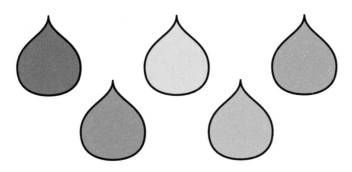

The colors used for this design were inspired by
the word "shine" itself. Try creating highlights,
or add sparkle with a white gel pen.

You were born to shine, so don't be afraid
to put yourself out there and show the world.

—Unknown

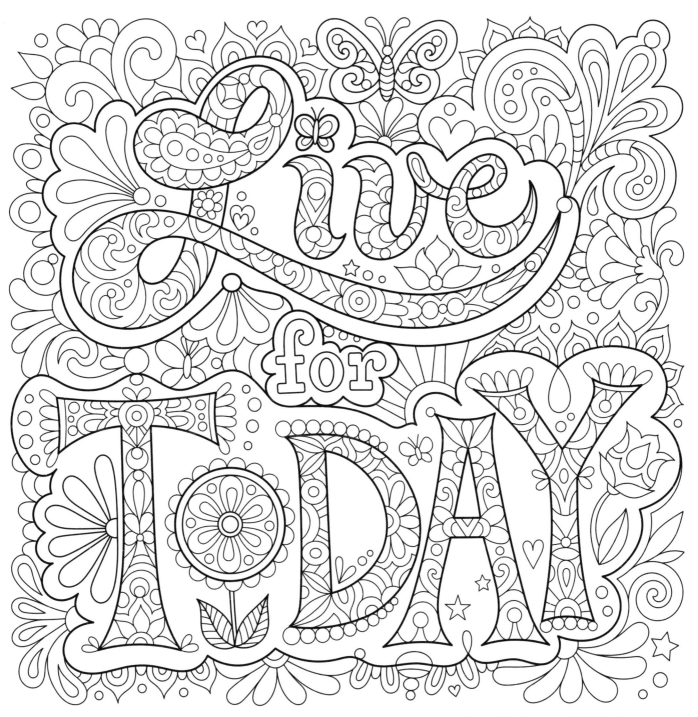

Help your letters stand out by using dark colors against a light background or light colors against a dark background.

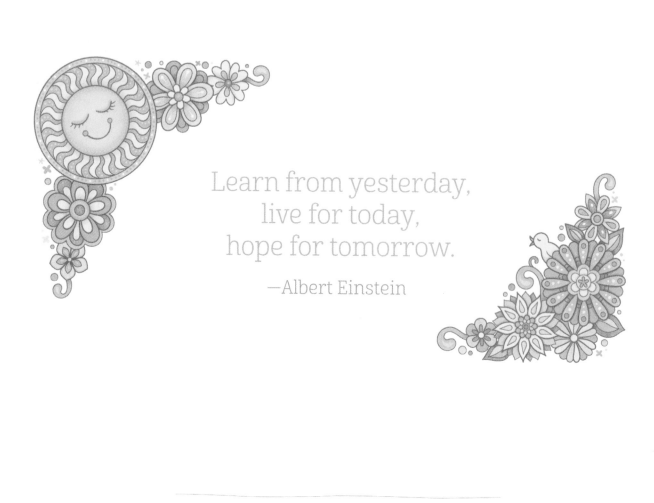

Learn from yesterday,
live for today,
hope for tomorrow.

—Albert Einstein

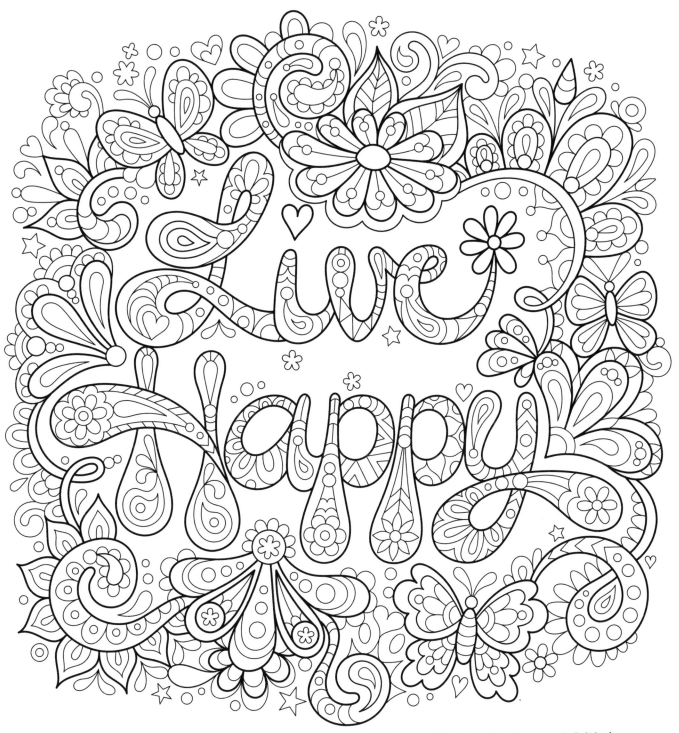

Warm colors like pink, red, and yellow
will give your design a lighthearted feel.

Whatever you decide to do,
make sure it makes you happy.

—Paulo Coelho

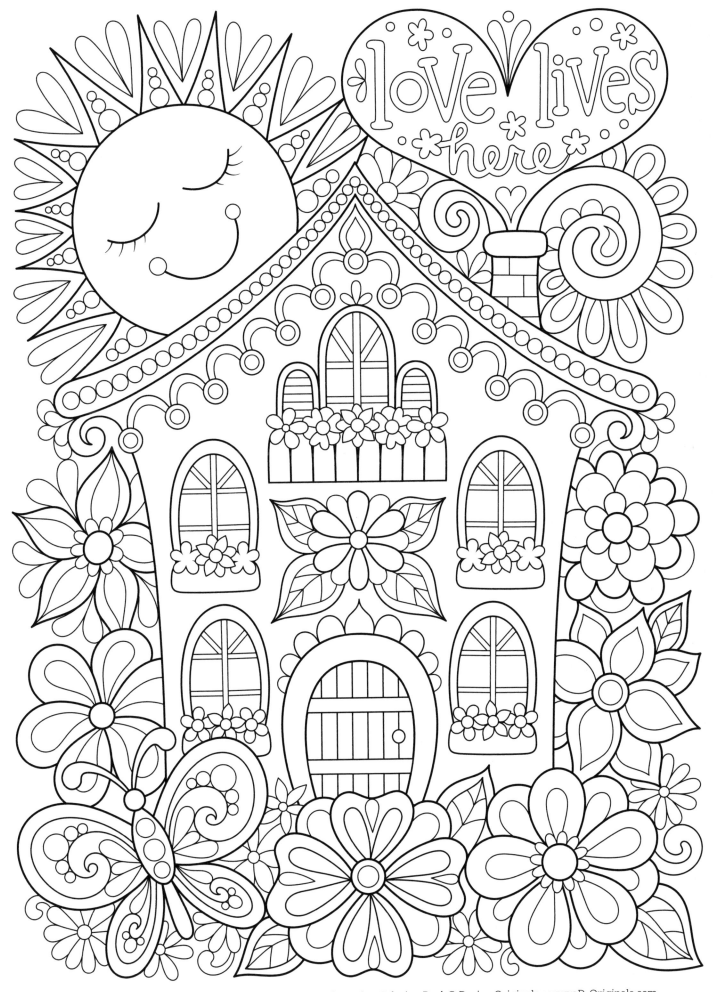

love lives here

It's the moments together
that change us forever.

—Unknown

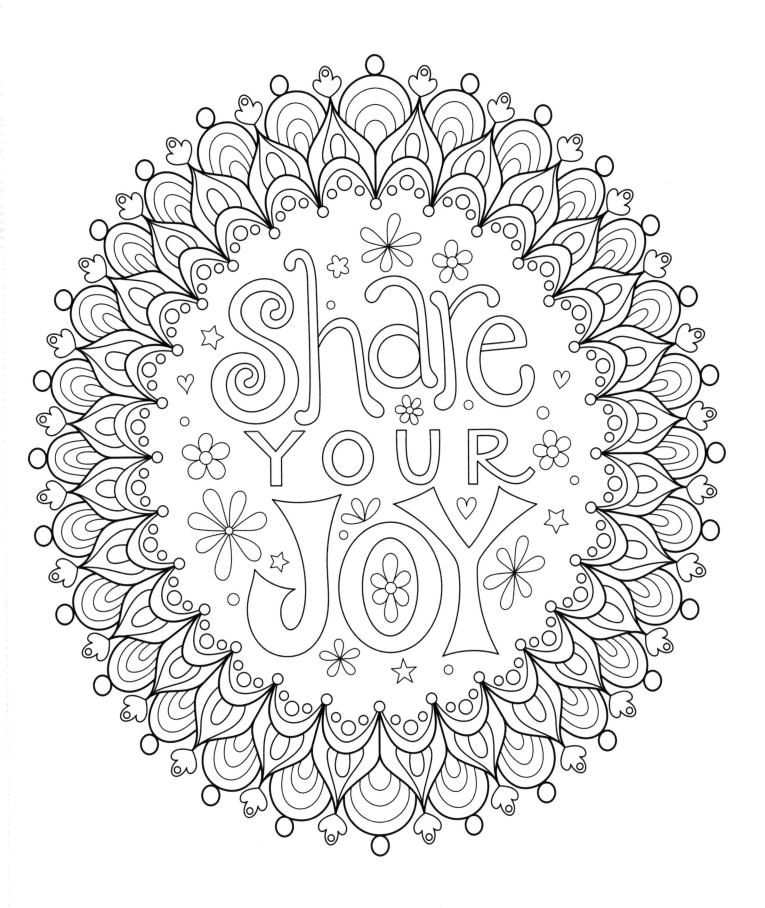

To get the full value of a joy you must have somebody to divide it with.

—Mark Twain

Say hello to new possibilities

Life always begins with
one step outside
your comfort zone.

—Shannon L. Adler

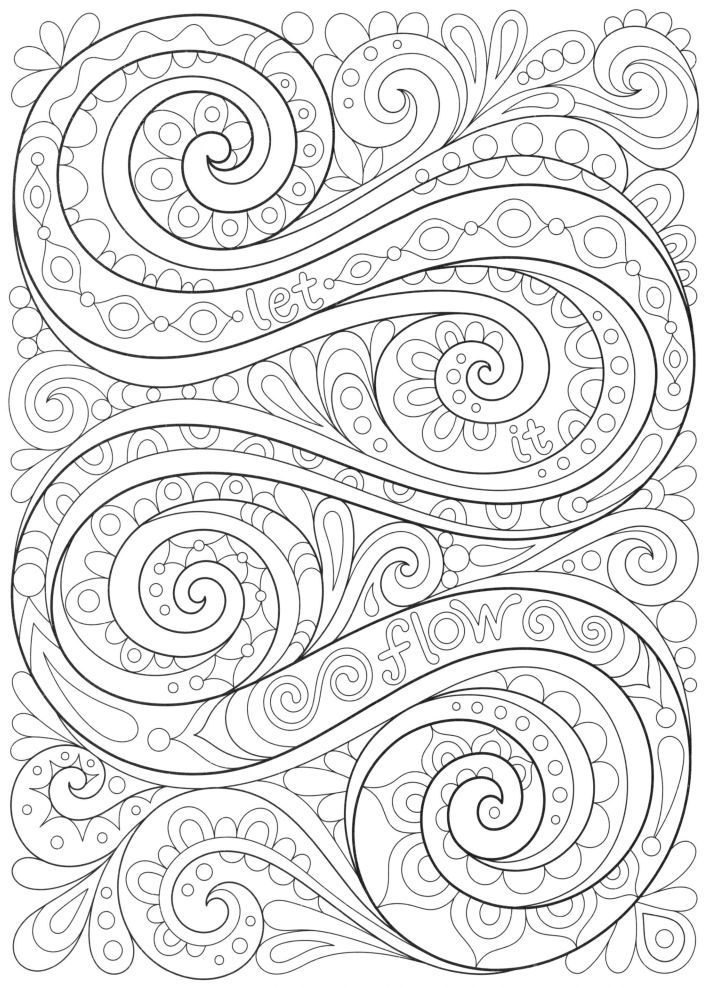

Let go a little and just let life happen.

—Unknown

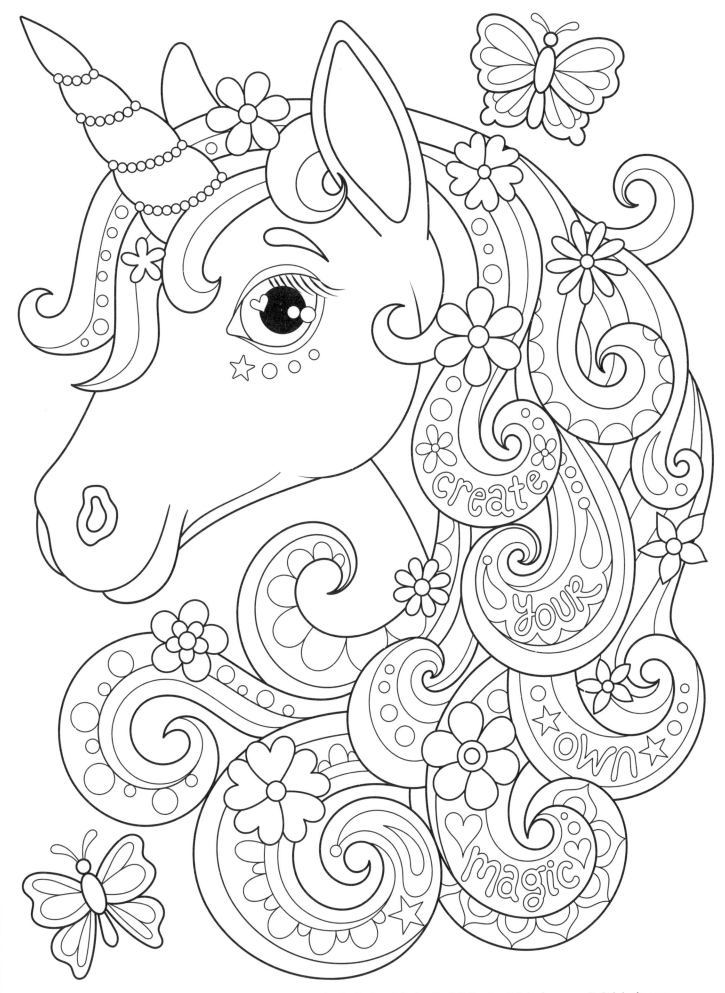

Magic is believing
in yourself, if you can
do that, you can make
anything happen.

—Johann Wolfgang von Goethe

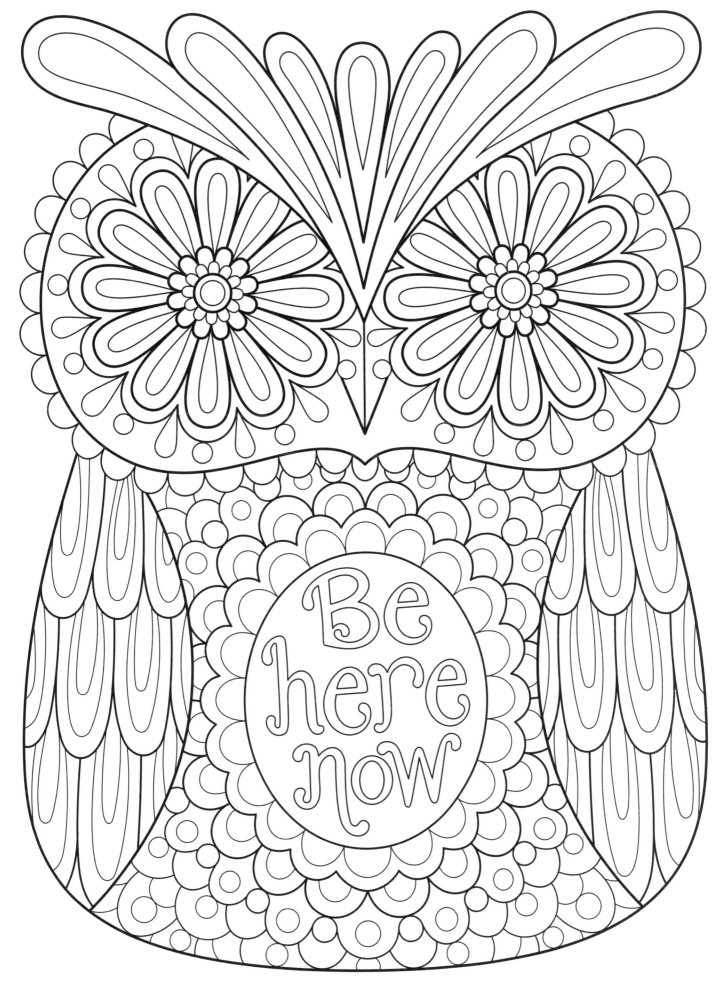

Be present in all things
and thankful for all things.

—Maya Angelou

Your time is limited,
so don't waste it living
someone else's life.

—Steve Jobs

The limit for love is limitless love.

—Francis de Sales

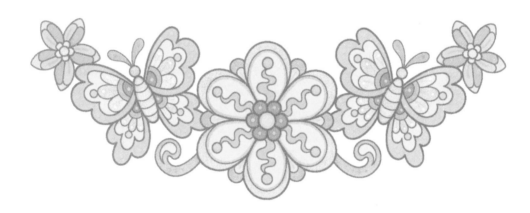

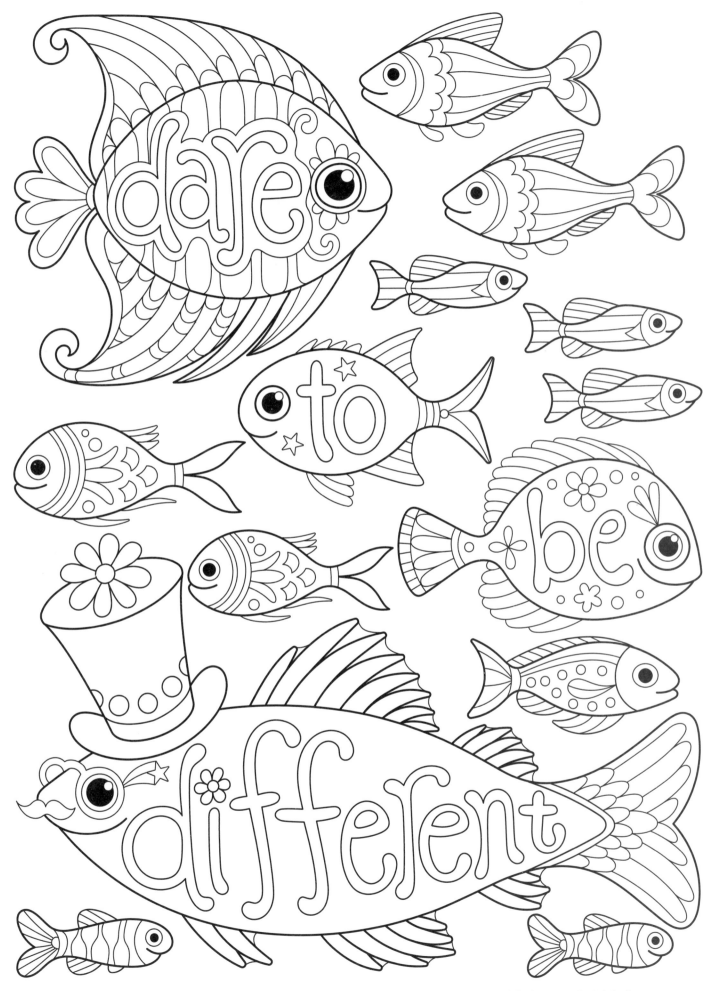

The things that make
me different are the things
that make me me.

—Winnie-the-Pooh

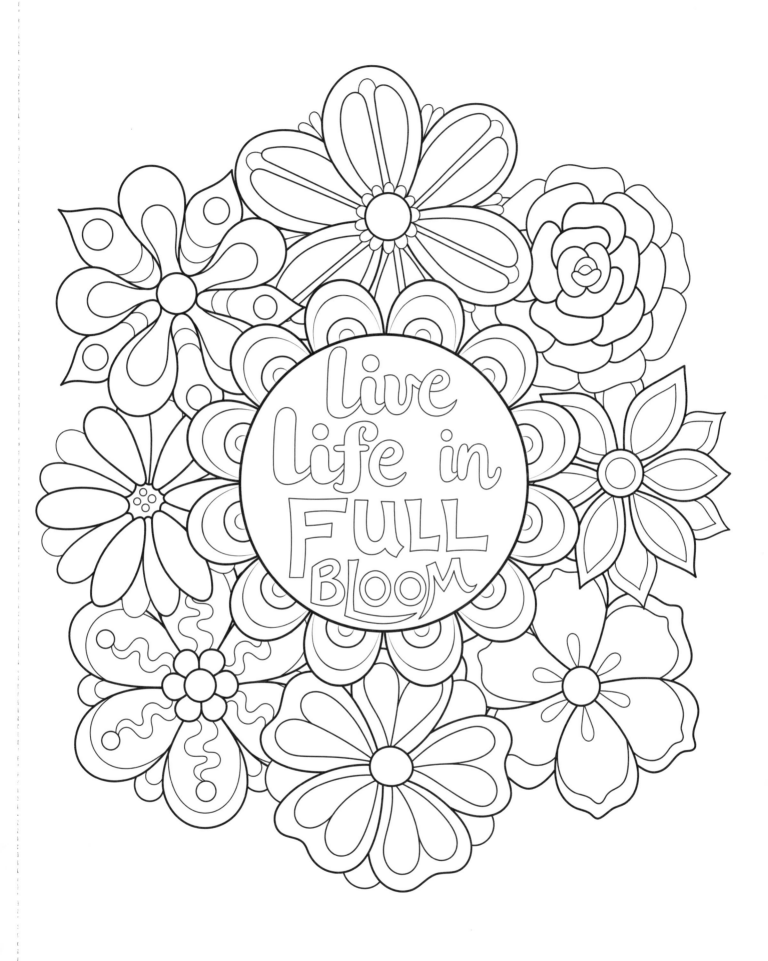

Wake each day excited
to bloom in a new way.

—Unknown

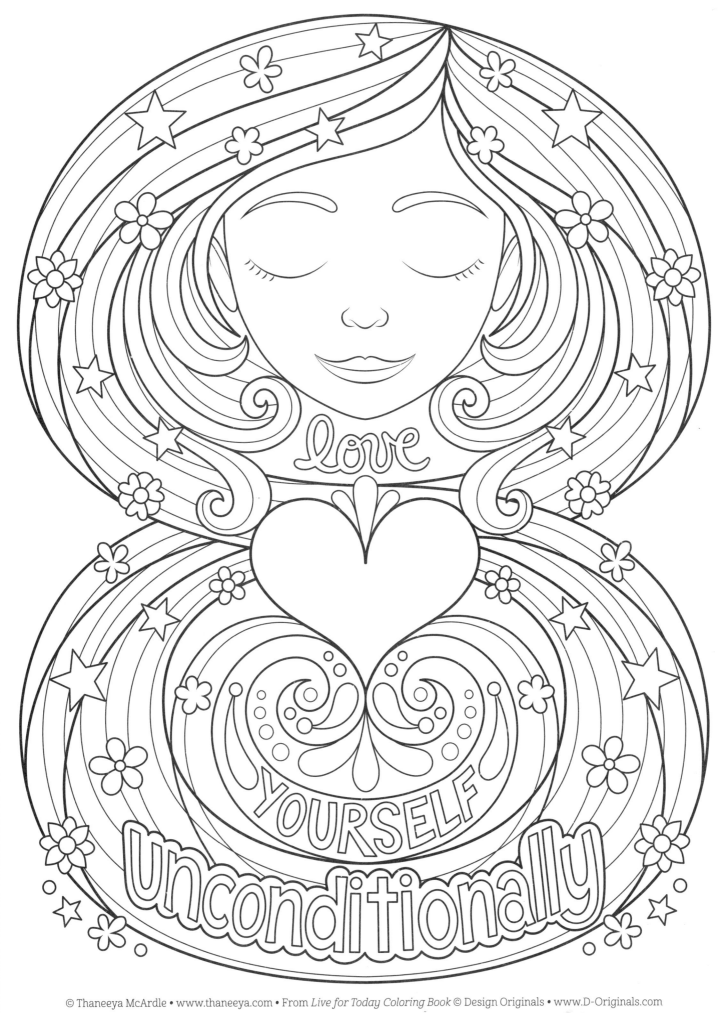

love

YOURSELF
unconditionally

You yourself, as much as
anybody in the entire universe,
deserve your love
and affection.

—Unknown

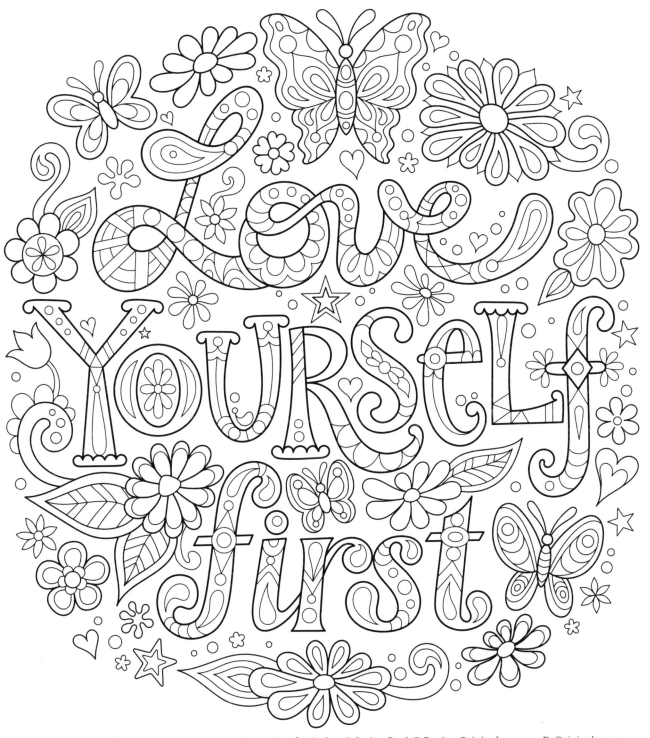

Try a monochromatic color scheme (tints and shades of
the same color) for each word in this design.

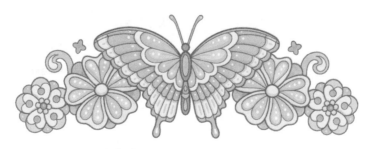

Love yourself first and everything else
falls into line. You really have to love yourself
to get anything done in this world.

—Lucille Ball

Cool blues, purples, and greens
will give your design a calm vibe.

Turn off your mind, relax,
and float downstream.

—The Beatles, *Tomorrow Never Knows*

This light and airy design pairs well with soft colors.

If you change the way you look
at things, the things you look at change.

—Wayne Dyer

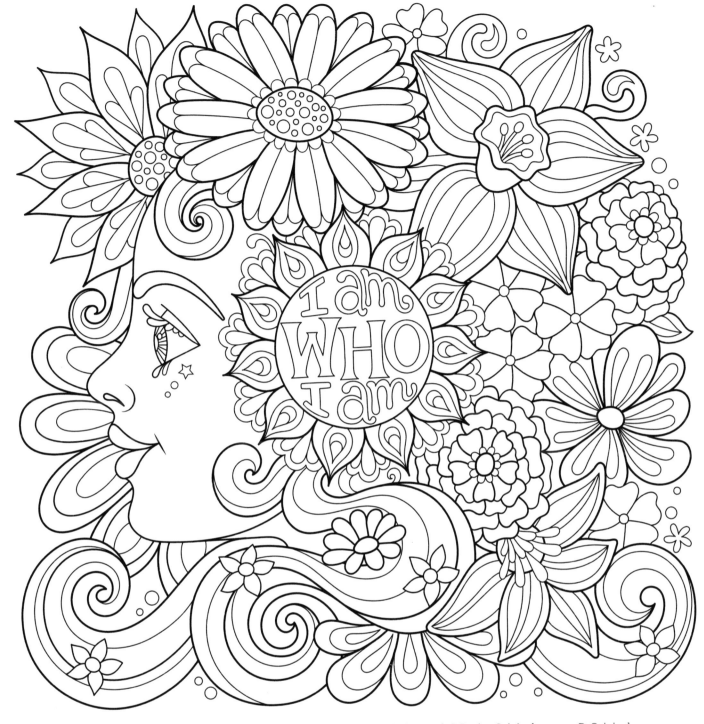

Do as this design says and be who you are
by using your favorite colors!

Just be yourself,
there is no one better.

—Taylor Swift

Reach outside your comfort zone and
try a color palette you've never used before.

Where's your will to be weird?

—Jim Morrison

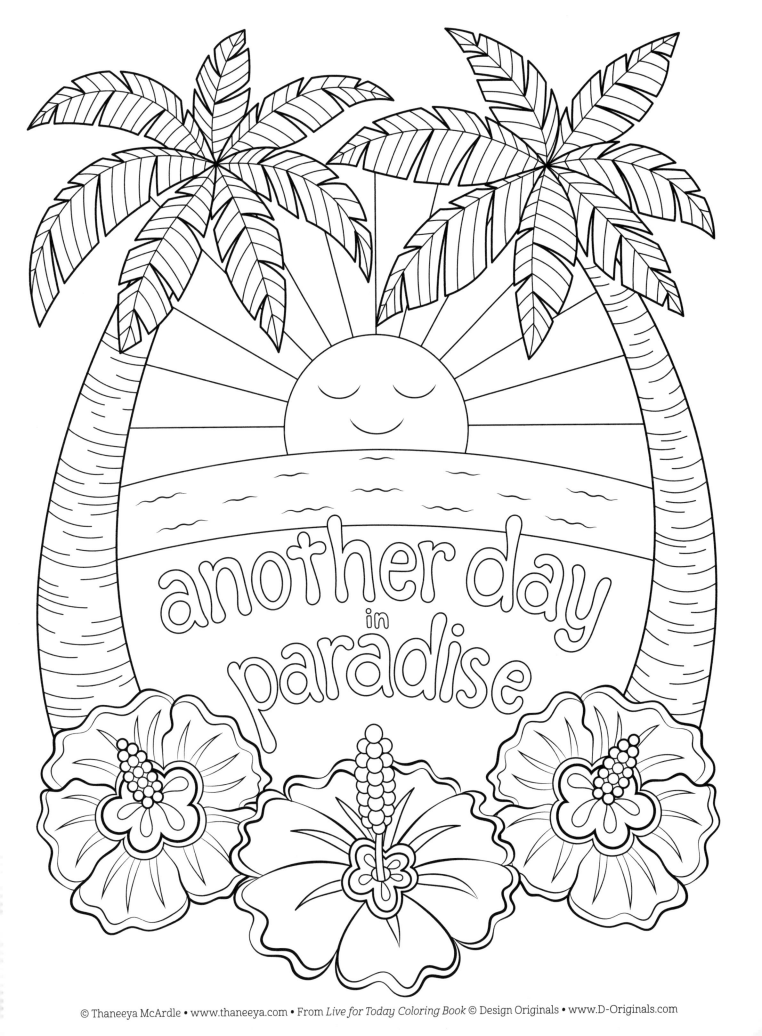

Paradise is not a place,
it's a state of mind.

—Unknown

find & express your own inner truth

A loud voice cannot compete
with a clear voice,
even if it's a whisper.

—Barry Neil Kauffman

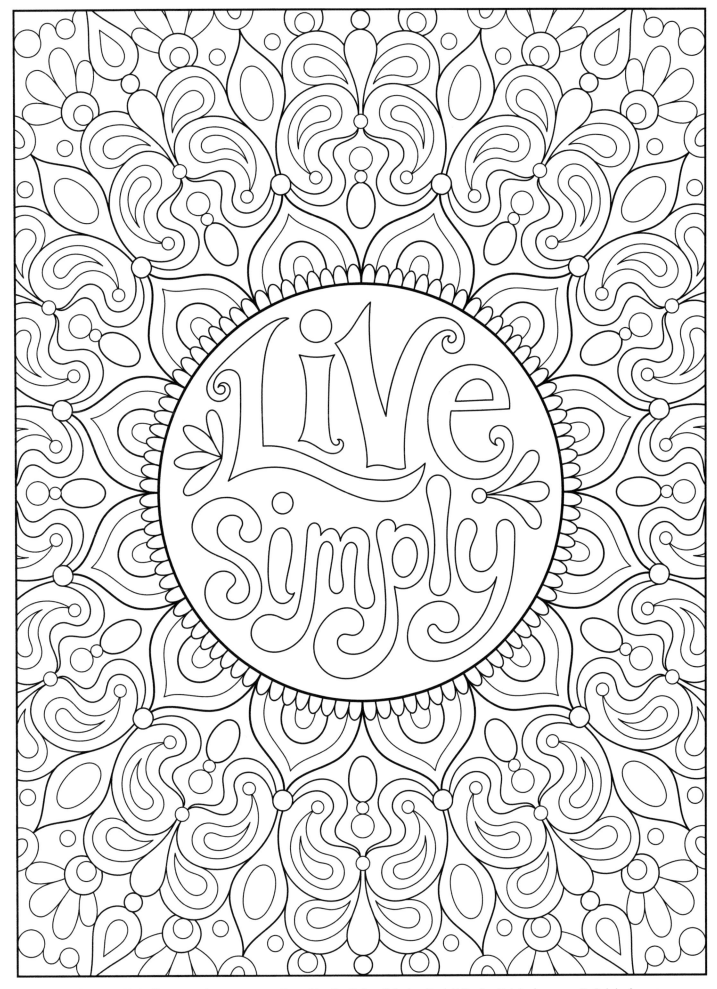

I have just three things to teach:
simplicity, patience, compassion.
These three are your greatest treasures.

—Lao Tzu

